DOUBLE EXPOSURE

AFRICAN AMERICAN WOMEN

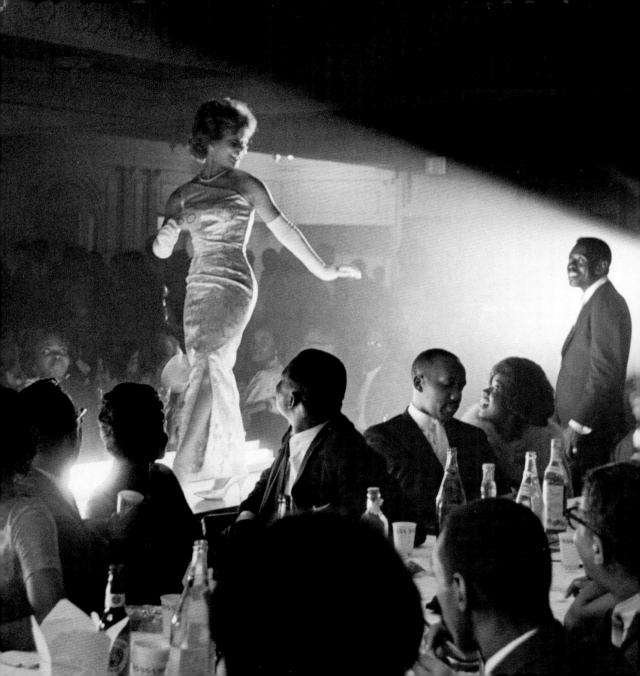

DOUBLE EXPOSURE

AFRICAN AMERICAN WOMEN

Photographs from the National Museum of
African American History and Culture

Smithsonian
*National Museum of African American
History and Culture*

Earl W. and Amanda Stafford
Center for African American Media Arts

GILES

National Museum of African American History and Culture
Smithsonian Institution, Washington, D.C., in association with D Giles Limited, London

For the National Museum of African American History and Culture
Series Editors: Laura Coyle and Michèle Gates Moresi

Curator and Head of the Earl W. and Amanda Stafford Center for African American Media Arts: Rhea L. Combs

Publication Committee:
Aaron Bryant, Rhea L. Combs, Laura Coyle, Michèle Gates Moresi, and Jacquelyn Days Serwer

For D Giles Limited
Copyedited and proofread by Jodi Simpson

Designed by Alfonso Iacurci and Helen McFarland

Produced by GILES, an imprint of D Giles Limited, London

Bound and printed in China

First published in 2015 by GILES
An imprint of D Giles Limited
4 Crescent Stables
139 Upper Richmond Road
London
SW15 2TN
www.gilesltd.com

ISBN: 978-1-907804-48-9

Smithsonian Institution, National Museum of African American History and Culture, Washington, D.C., in association with GILES, an imprint of D Giles Limited, London.

All measurements are in inches and centimeters; height precedes width precedes depth.

Photograph titles: Where a photographer has designated a title for his/her photograph, this title is shown in italics. All other titles are descriptive, and are not italicized.

Front cover: *Untitled*, May 1947
Lena Horne backstage at the Chez Paree
From the series The Way of Life of the Northern Negro (detail)
Wayne F. Miller
Back cover: Sojourner Truth, ca. 1866, Unidentified photographer
Frontispiece: *Harlem Beauty Contest · New York, New York*, 1963; printed 1998 (detail), Leonard Freed
Page 6: Unidentified woman, ca. 1900 (detail), Ramsdell Photo Artist

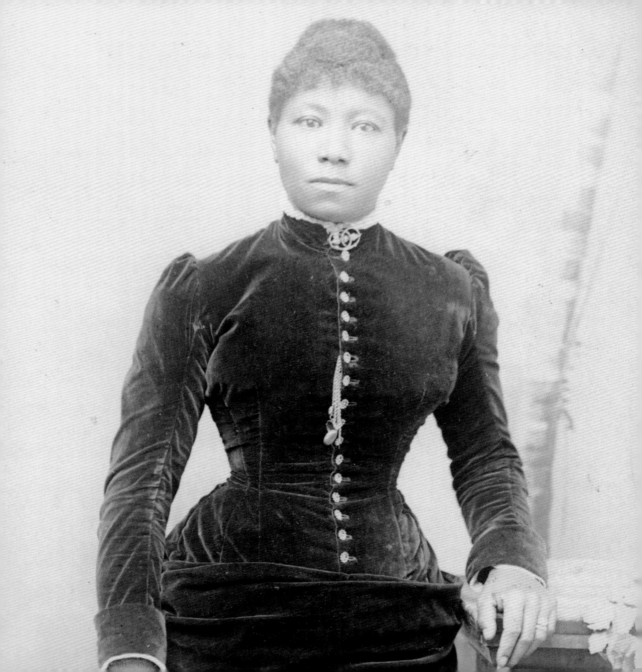

Foreword

In my journey as a historian telling stories via the museum, I have been struck time and again by the power of photographs. It is often a photograph of an unknown individual that captures my imagination. This was certainly the case when I was presented with the donation of a family photo album—for a family now without a name. Many images of African Americans from the early twentieth century that have made their way into the popular imagination are portraits of poverty and hardship. However, this album, a collection of cabinet cards, presents middle-class blacks who were largely invisible to mainstream white America. The photographs convey a sense of pride and self-worth that are remarkable in an era of legal segregation and circumscribed civil rights. They remind us that period images of blacks picking cotton are only part of the story. What also struck me in this album is the rich array of wonderful images of women portrayed with dignity and poise.

As a museum of the twenty-first century, the National Museum of African American History and Culture (NMAAHC) has begun to document diverse experiences that allow us to view American stories through an African American lens. *African American Women* is the third book in a series of publications, *Double Exposure*. It draws on the Museum's growing photography collection of over 15,000 images, which also supports our innovative Earl W. and Amanda Stafford Center for African American Media Arts (CAAMA). CAAMA, as a physical and virtual resource within NMAAHC, exemplifies the Museum's dedication to preserving the legacies of black history and culture. With this volume, we share a selection of images that focus on the central role of women in black communities, a role so often taken for granted.

Women's activities in the black community—or any community throughout the world—are so frequently behind the scenes: birthing babies, raising children, keeping order, registering citizens to vote, teaching in rural and urban schools, ministering to the poor, singing in the church. Who in the black community cannot cite a strong influential woman in his or her life, someone who defied the odds and set an example that stayed with them for life? The grandmother who preached hard work and thrift; the daughter who got straight As; the aunt who always held her head high; the sister who kept the family together in a time of crisis; the mother who reared her children mainly on her own? This book searches for the evidence that underlies deeply held mythologies and confirms the truths within them. But this book goes further and also celebrates those who stood up and stood out, those who took public leadership roles, too often passed over or forgotten in the history books.

Kinshasha Holman Conwill, Deputy Director of NMAAHC, considers a related theme in her essay "Picturing Grace." Exploring race, gender, and the varied roles black women have played, she suggests to us a way not only to look at these photographs, but a way to see them as significant narratives in African American—and American—history.

I am grateful to our nation's Poet Laureate (2012–14) Natasha Trethewey for contributing her poems "Gesture of a Woman-in-Process" and "Wash Women." She also shares with us insights on her writing process that reinforce how the power of the visual medium of photography can be both a uniquely personal experience and a collective one.

Many people contributed to the making of this important book and landmark series. At the Museum, special acknowledgement is due to the publications team: Jacquelyn Days Serwer, Chief Curator; Michèle Gates Moresi, Supervisory Curator of Collections, who acted as team leader on this project; Rhea Combs, Curator of Photography and Film, and Head of the Stafford Center for African American Media Arts; Laura Coyle, Head of Cataloging and Digitization, whose work made the reproduction of these photographs possible; and Aaron Bryant, Mellon Curator of Photography.

We are also very fortunate to have the pleasure of co-publishing with D Giles Limited, based in London. At Giles, I particularly want to thank Dan Giles, Managing Director; Alfonso Iacurci and Helen McFarland, Designers; Allison McCormick, Editorial Manager; Sarah McLaughlin, Production Director; and Jodi Simpson, Copyeditor. Others who deserve my thanks include Rex Ellis, the Museum's Associate Director for Curatorial Affairs, Lisa Ackerman, Terri Anderson, David Braatz, Emily Houf, Alexander Jamison, Leah L. Jones, Christopher Louvar, Kirah Nelson, Erin Ober, T. Greg Palumbo, Douglas Remley, and Jennie Smithken-Lindsay.

I am so pleased to continue this series with images of women and to share even this small selection with our public. We remain steadfast in our commitment to document African American history, and, like me, I trust you will be inspired by the photography collections at the Smithsonian and beyond.

Lonnie G. Bunch III
Founding Director
National Museum of African American History and Culture, Smithsonian Institution

Picturing Grace

Kinshasha Holman Conwill

Deputy Director, National Museum of African American History and Culture

"Only the BLACK WOMAN can say 'when and where I enter, in the quiet, undisputed dignity of my womanhood, without violence and without suing or special patronage, then and there the whole...race enters with me.'" —Anna Julia Cooper, 1892[1]

The title of Paula Giddings's landmark book *When and Where I Enter: The Impact of Black Women on Race and Sex in America* derives from the words of Anna Julia Cooper (1858–1964). Cooper was born enslaved and went on to lead a long and distinguished life as a writer, scholar, educator, and intellectual leading light. Giddings's choice of Cooper as a touchstone for her study of black women is especially fitting given the latter's unwavering curiosity and unflinching courage over decades when the status of black people and black women—especially "the undisputed dignity of [their] womanhood"— was constantly being contested.

The women and girls pictured in this volume are heirs and beneficiaries of that legacy of determination against all odds. In images that range from dignified and direct to coy and sassy, from the glamour of Leonard Freed's 1963 unidentified beauty contestant (see p. 64) to the determined visage of Harriet Tubman in a studio portrait (see p. 10), we encounter an amazing group of subjects who compel us to take notice. Whether they are known or unknown, they draw in the viewer with gazes (even when averted) and expressive body language and stances that are arresting and singular. The photographers of this extraordinary gallery of humanity are as varied as the figures they capture. They read like a roll call of some of the twentieth century's most prolific practitioners, including Arthur Bedou, Dawoud Bey, Henri Cartier-Bresson, Leonard Freed, Lewis Hine, Aaron Siskind, W. Eugene Smith, Carl Van Vechten, and Ernest C. Withers. Each illuminates a narrative that reflects large and small moments in U.S. history and culture from the era of enslavement and the Civil War to the time of the Freedom Movement and the beginning of the Age of Obama—a long and turbulent century and a half marked by the

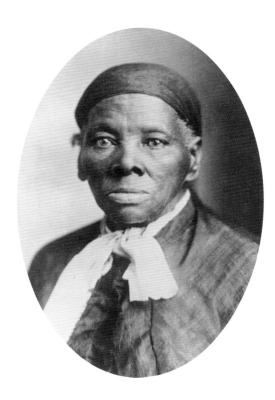

Harriet Tubman, ca. 1908;
printed ca. 1920
Tarby Studios

transformation of the condition of black women from newly emancipated (but still second-class citizens with no voting rights) to pioneers in education, activism, law, medicine, business, the arts and entertainment, and much more.

The dearth of women photographers represented here, while not an exact numerical corollary to those in the field, is a telling reminder that in some arenas women are still under-represented. Happily, the ranks of women photographers continue to grow, as will their representation in the collection of the National Museum of African American History and Culture.

The gendering of African American history and culture is a fraught enterprise writ large. How do we identify where and when black women enter the narrative in ways that respect their undeniable contributions, while avoiding tokenism or paternalism? How do we lay bare the sometimes brutal truths of their lives without sensationalism? Most importantly, how do we tell a story that, in its complexity and nuance, becomes revelatory?

Photography, with its layered interpretations, is an especially agile medium for such a journey of discovery and revelation. The reveal for each image in this book ranges broadly, suggesting, both for this volume and any future presentation of these works, distinct possibilities to learn

more, to dig deeper into the rich stories these images embody and mine them for additional treasure. Whether for the curious general viewer or the serious scholar, opportunities abound to uncover more knowledge about an anonymous figure, or to delve into the biography of a lesser-known photographer. The path is as variegated as the path makers.

Some subjects, such as Lena Horne, represented here in a photograph from the series *The Way of Life of the Northern Negro* (1946–48) (see p. 65), are well known, though her photographer Wayne F. Miller is hardly a household name. In other cases, both Aretha Franklin and Memphis photographer Ernest C. Withers, who photographed Franklin during the 1968 Southern Christian Leadership Conference (SCLC) convention (see p. 63), are known—especially by those already knowledgeable of American music and African American culture.

One of the most intriguing photographs, and one about which we know relatively little, is a carte-de-visite of an unidentified African American woman (ca. 1870) by Edward M. Estabrooke. This image is in the tradition of such photographs, which came into use and popularity in the Civil War era. The subject's formal attire of bonnet, cloak, and full-length

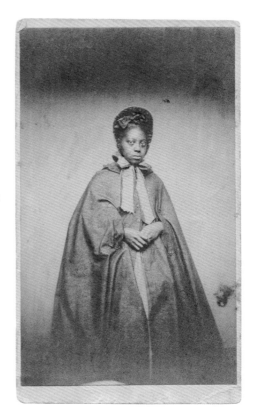

An African American woman, ca. 1870
Edward M. Estabrooke

dress, indicative of the fashion of the late nineteenth century, marks her as someone attentive to her appearance and presumably of sufficient means to afford to dress well. And while her demeanor might be read as somewhat wary—her hands are clasped firmly in front of her, her eyes have neither the studied preoccupation nor the straight-ahead stance of other such photos—she has a real presence.

While this image is an albumen print, Estabrooke was an expert on the ferrotype, a kind of tintype. His 1872 publication *The Ferrotype, and How to Make It* gives an exhaustive account of what it is (and isn't) in the language of a true believer in the larger context of the then-short history of photography. He also has strong ideas on how to pose subjects, and his prescription for the ideal approach to portraits of women acts as an apt descriptor of how the mysterious woman in this portrait was captured:

> With the female standing figure, there is much less difficulty; the lines of the dress tend to support each other, and the drapery, gracefully flowing, removes any appearance of stiffness incidental to the position.[2]

We know much more about the photographer Joe Schwartz (1913–2013), a self-professed "folk photographer," most active from the 1930s to the 1980s, who was determined to portray "the plight of the 'have-nots'" and committed to interracial harmony. The Museum is the fortunate recipient of a donation of a corpus of Schwartz's work in the form of prints and digital images, including his 1940s portrait of an unidentified child in Brooklyn (see p. 53), where Schwartz photographed a racially mixed community. Schwartz subsequently titled the photo *Miss America* in a gesture befitting his aspirations and worldview. While we know little about who the child is, we do know that this resolute and dignified young girl was a part of that community. Part of what draws us in is the determination so evident in her countenance and her confident stance as she observes her observer, arms crossed, with just the slightest hint of disapproval, or at the least, skepticism.

On the surface, the photo of the versatile and multitalented Ethel Waters (1896–1977) by the well-known critic, writer, photographer, and Harlem Renaissance denizen and patron Carl Van Vechten (1880–1964), is a perfect marriage of famous sitter and famous photographer. The literature on both provides keys that allow one to "read" the photograph in ways not possible in the case of the elegant,

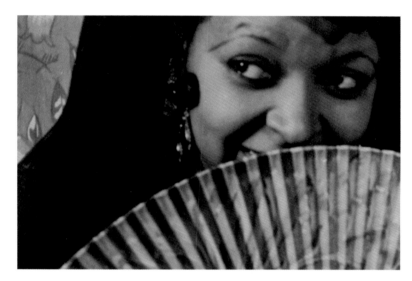

Ethel Waters as Carmen,
April 30, 1934 (detail)
Carl Van Vechten

unknown nineteenth-century woman and the fascinating twentieth-century child. Ethel Waters and Carl Van Vechten were more than model and photographer; they were friends. Van Vechten photographed Waters many times. Indeed, his portraits of African American entertainers, musicians, visual artists, writers, and other cultural figures was a "who's who" of black America, especially in the 1930s and 1940s, the period contemporaneous with the Waters portrait.

And many of those he photographed in those years were black women, including Marian Anderson, Pearl Bailey, Josephine Baker, Mary McLeod Bethune, Lena Horne, Zora Neale Hurston, Rose McClendon, Pearl Primus, Augusta Savage, Philippa Schuyler, and Bessie Smith.[3]

Waters, in a career that spanned six decades, was a singer of jazz, blues, and gospel; a vaudeville headliner, and a popular recording artist, as well as a renowned

stage and screen actress. In Van Vechten's 1934 photograph of Waters as Carmen (see p. 13), she strikes a seductive pose befitting the siren she is portraying: fan poised close to her face, below eyes whose lids one can imagine fluttering in order to perfect the come-hither look captured by the photographer. It is a refreshingly different image of the great lady perhaps better known for roles that virtually defined Broadway's and Hollywood's vision of the stalwart black matriarch or family servant in plays and films. These include major parts in the films *The Member of the Wedding* and *Pinky*, and the title role in the television comedy series *Beulah*, as well as her performance in 1940 as the long-suffering wife Petunia Jackson to Dooley Wilson's "Little Joe" Jackson in the stage production of *Cabin in the Sky*. She reprised the role in the screen version, where Eddie "Rochester" Anderson played her husband.

Ethel Waters, like other African American female and male performers, had to carefully navigate the very rough waters of American entertainment through periods of enormous and active resistance to their mere presence, much less their success. She was a pioneer and found the fortitude to enter, though not quietly, and left her mark with extraordinary dignity. Whether saucy,

defiant, joyful, or enigmatic, Waters and the other women in this publication found their way in their families and local communities, on national stages and in the international arena—and many of them entered history— with extraordinary grace.

Endnotes

1. Anna Julia Cooper, *A Voice from the South* (1892; repr. New York: Oxford University Press, 1988), 31, quoted in Paula Giddings, *When and Where I Enter: The Impact of Black Women on Race and Sex in America* (New York: William Morrow, 1984), n.p.

2. Edward M. Estabrooke, *The Ferrotype, and How to Make It* (Cincinnati and Louisville, KY, 1872), 12.

3. Van Vechten's subjects of the period were not all African American by any means. It is significant that he was also photographing a national and international array of figures in the world of arts and letters and clearly counted black women— and men—in that number. The very long list included Harold Arlen, James Baldwin, Tallulah Bankhead, Ethel Barrymore, Thomas Hart Benton, Alexander Calder, Jacob Lawrence, Langston Hughes, Alicia Markova, and Gertrude Stein. He was Stein's literary executor.

Ars Poetica

Natasha Trethewey
United States Poet Laureate (2012–14)

My work as a poet always begins in *seeing*, and in its earliest form that seeing was both *watching* the work of my grandmother and other women in my family and the small community of North Gulfport, Mississippi, and *imagining* it— picturing in my head scenes from the stories they told me about their lives. Later I began to work with photographs,[1] to *read* them, finding there the visual language for my poems, a way to focus on image as the means to investigate our personal and collective history, as well as the ongoing presence of the past in our contemporary moment. The poem "Gesture of a Woman-in-Process" tries to get at that notion, how we can see in the photograph a larger story than what is contained in the frame—in this case, the figurative implication in the action of the one woman who *won't be still*. In her movement she creates a swirl in the center of the photograph, an energy that suggests that she is not willing to be simply trapped in history, not a flat representation or a passive object of our contemporary gaze, but a vital force still compelling us to consider her as a creator of the living past, showing us a new way of seeing.

Gesture of a Woman-in-Process
—from a photograph, 1902

In the foreground, two women,
their squinting faces
creased into texture—

a deep relief—the lines
like palms of hands
I could read if I could touch.

Around them, their dailiness:
clotheslines sagged with linens,
a patch of greens and yams,

buckets of peas for shelling.
One woman pauses for the picture.
The other won't be still.

Even now, her hands circling,
the white blur of her apron
still in motion.

In this collection, I encounter several images that recall for me my family history—particularly W. Eugene Smith's 1951 photograph of Maude E. Callen, the South Carolina nurse and midwife, standing in the road with two other women. Callen carries a notebook and the two women hold objects that seem to be associated with going to market or taking in wash: a cloth bundle hooked on one woman's arm, a small tub balanced on the other one's head. Looking at it I am reminded of another photograph—one that inspired my poem "Wash Women"—in which eight women walk down a long road, not unlike the road in Smith's photograph, carrying bundles of laundry on their heads.

Wash Women

The eyes of eight women
I don't know
stare out from this photograph
saying *remember*.
Hung against these white walls,
their dark faces, common
as ones I've known,
stand out like some distant Monday
I've only heard about.
I picture wash day:
red beans simmering on the stove,
a number three tin tub
on the floor, well-water ready

to boil. There's cook-starch
for ironing, and some
left over to eat.

I hear the laughter,
three sisters speaking
of penny drinks, streetcars,
the movie house. A woman
like my grandmother rubs linens
against the washboard ribs,
hymns growling in her throat.
By the window, another
soaks crocheted lace, then presses
each delicate roll, long fingers
wet and glistening.
And in the doorway, the eldest
shifts her milk-heavy breasts,
a pile of strangers' clothes,
soiled, at her feet.

But in this photograph,
women do not smile,
their lips a steady line
connecting each quiet face.
They walk the road toward home,
a week's worth of take-in laundry
balanced on their heads
lightly as church hats. Shaded
by their loads, they do not squint,
their ready gaze through him,
to me, straight ahead.

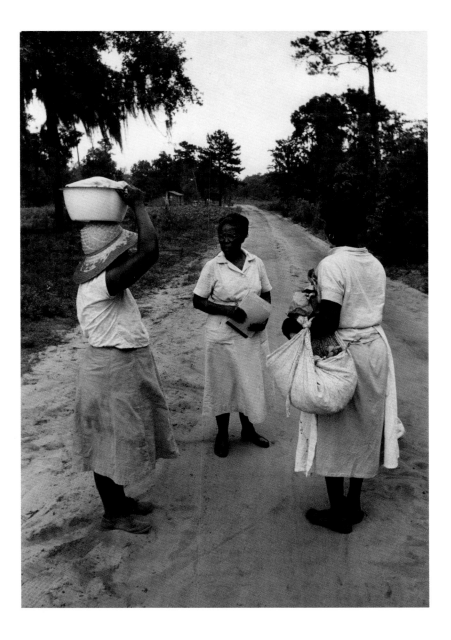

Untitled, 1951
W. Eugene Smith

17

In Smith's photograph, not only do the objects the women carry remind me of family history, but the context beyond the visual is compelling too—the work of the midwife in a particular historical moment. That the women might have been coming from the market makes me think of my grandmother's stories about "making groceries" at the French market in New Orleans the year my mother was born. Perhaps, too, the little house in the background evokes another connection—the suggestion of a kind of isolation I imagine when I think of my grandmother in 1944, alone in her house, in labor and waiting for help.

I've heard this story again and again: how, when the contractions began, my grandmother called to a woman passing by to fetch the midwife; how the baby came before the midwife could get there; how mother and daughter lay for some time, still joined by the cord. That they stayed joined so long without someone to separate them makes literal the metaphor of the abiding connection between mother and child: it's the body's memory of what had bound them one to the other—the phantom ache, like grief, I feel at my navel whenever I think of my long-dead mother. And then there is Maude E. Callen, carrying her notebook, making me think of the writer—the poet I am—whose work to record the history I've been given is implied by the ordinary object the photographer captured in her hands.

Photographs have the power to do this—to evoke strong emotions, to connect us to the lives of others, and to compel us to necessary reckoning. In the gestures of the women pictured, in their enduring gazes and the stories their bodies convey, we find a link to the past that demands our engagement, another way of seeing it, and an invocation to remember—which is, for me, the enactment of that vital intersection between personal and public history from which my poems are made.

Endnotes

1. The poems that appear in this essay were inspired by photographs in Clifton Johnson's series *American Highways and Byways*. The Clifton Johnson Collection is a part of Special Collections at the Jones Library in Amherst, Massachusetts.

PHOTOGRAPHS

**Helen Ann Smith
at Harlem House,
Beale St., Memphis,
Tennessee**, 1950s
Ernest C. Withers

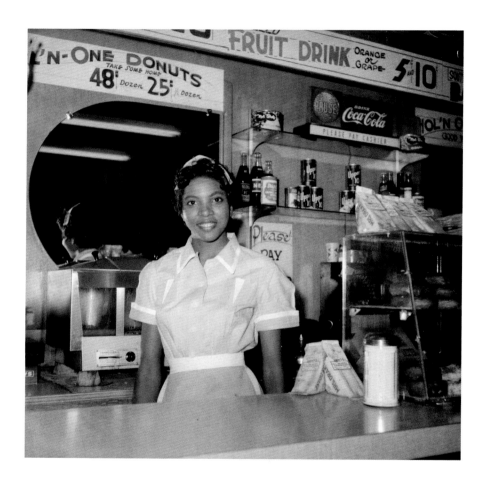

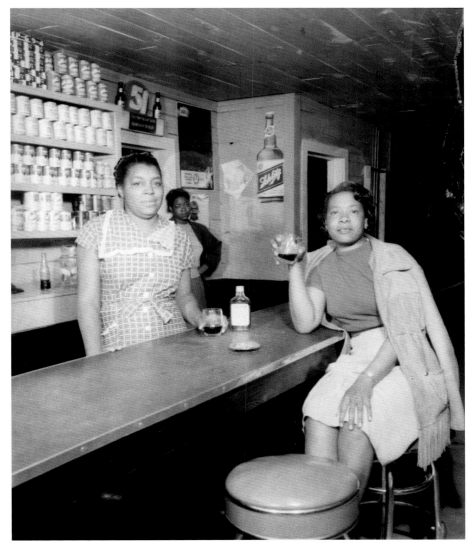

Three women, 1950s
Rev. Henry Clay
Anderson

Untitled, ca. 1980
Milton Williams

**Women in a beauty
pageant**, 1950s
Rev. Henry Clay
Anderson

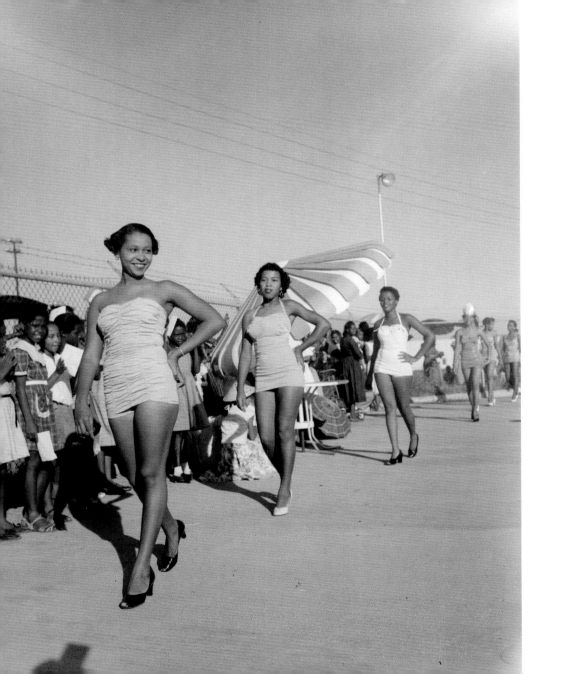

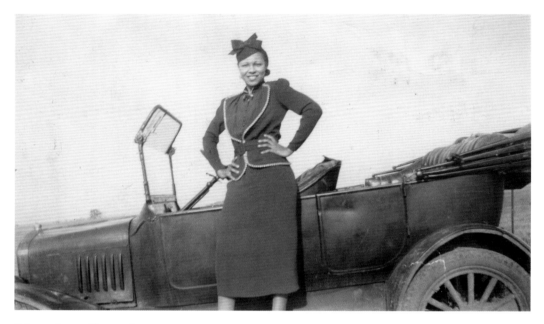

**Odessa Jones Murray in
front of a car**, ca. 1940
Unidentified photographer

*"If I didn't define myself for myself, I would be
crunched into other people's fantasies of me and
eaten alive."*

Audre Lorde, 1984

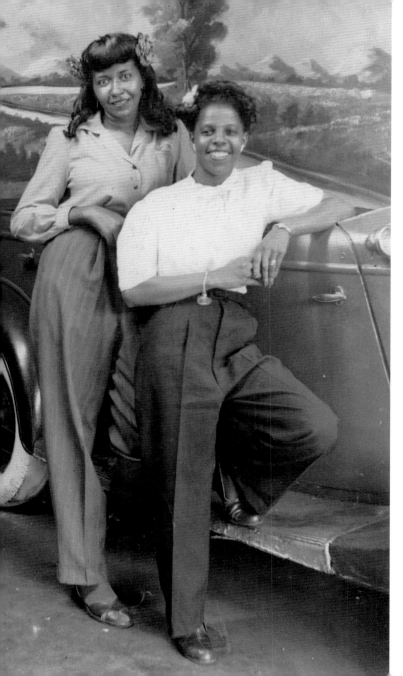

**Linnie King and
Virginia Bryant
Williams**, 1941
Unidentified
photographer

Sojourner Truth, ca. 1866
Unidentified photographer
—
Born into slavery and originally
named Isabella Baumfree,
Sojourner Truth (ca. 1797–1883),
escaped to freedom in 1826
with her infant daughter. After
going to court to recover her
son, she became the first black
woman to win such a case.
Truth worked tirelessly as an
abolitionist and women's rights
activist. She sold cabinet cards
of herself promoting the cause
of justice and equality that said,
"I sell the shadow to support the
substance." In her best-known
speech on gender inequalities,
Truth reportedly challenged the
audience at the Ohio Women's
Rights Convention in Akron with
the refrain, "Ain't I a Woman?"

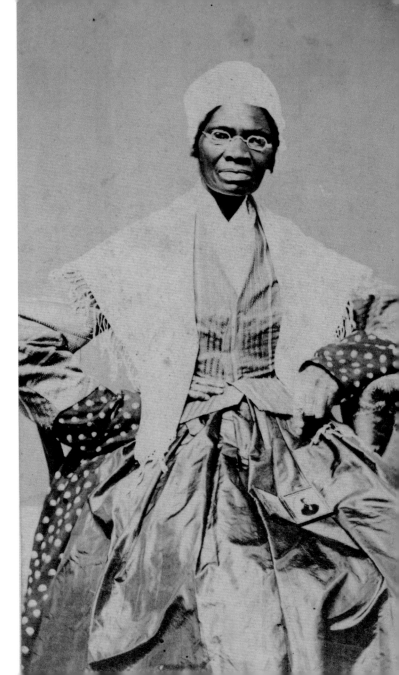

"That man over there says that women need to be helped into carriages, and lifted over ditches, and to have the best place everywhere. Nobody ever helps me into carriages, or over mud-puddles, or gives me any best place! And ain't I a woman? ... I could work as much and eat as much as a man—when I could get it—and bear the lash as well! And ain't I a woman? I have borne thirteen children, and seen most all sold off to slavery, and when I cried out with my mother's grief, none but Jesus heard me! And ain't I a woman?"

Attributed to Sojourner Truth, 1851

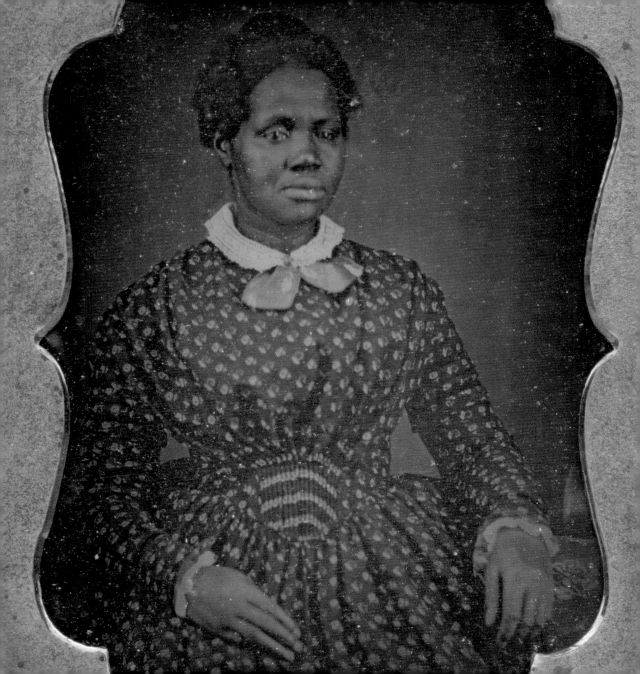

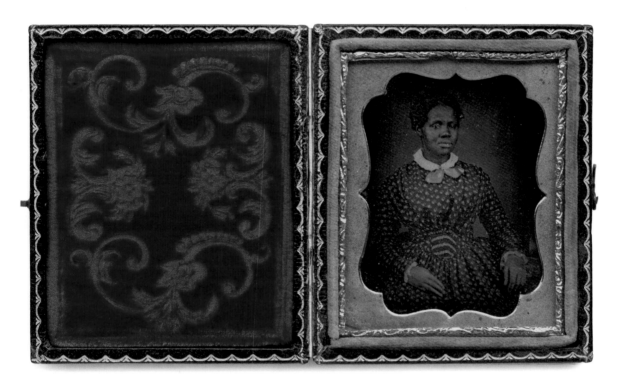

Rhoda Phillips,
ca. 1850
Unidentified
photographer

Rhoda Phillips (1831–1906) was born into slavery and owned by the Clark-Gleaves family of Nashville, Tennessee. After Emancipation, Phillips remained with the Gleaves family and worked for them as a servant for the rest of her life. When she died, she was interred by her employer in his family's plot in Mt. Olivet Cemetery in Nashville.

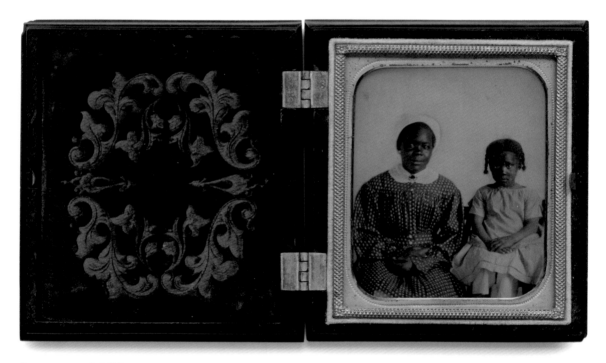

A woman and child,
ca. 1860
Unidentified
photographer

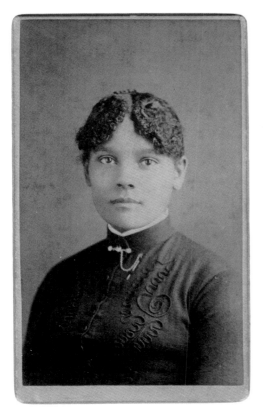

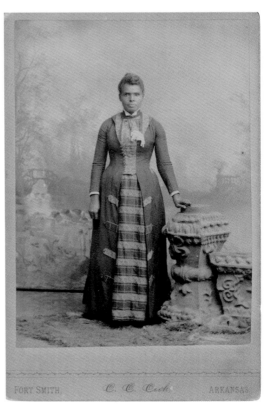

Mattie Gray Anthony,
ca. 1865
C. S. Judd

A woman, ca. 1885
C. C. Cook

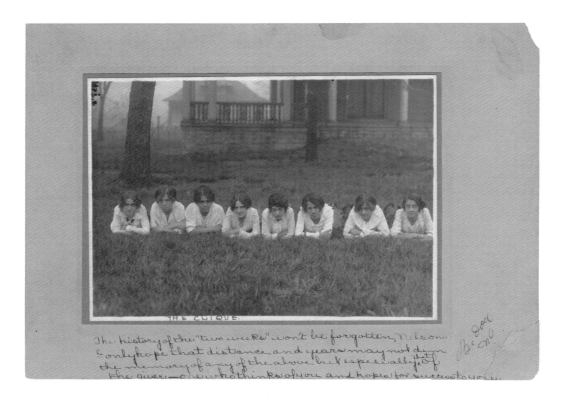

THE CLIQUE.

The history of the "two weeks" won't be forgotten. Nelson. I only hope that distance and years may not dim the memory of any of the above but especially that of the giver—one who thinks of you and hopes for success to you.

Bedou

The Clique, Fisk University Campus, 1915
Arthur P. Bedou

Bedou is best remembered as the photographer of Booker T. Washington, the legendary president of Tuskegee Institute (now University). Here, Bedou demonstrates his skill with a very different subject—students at Fisk University, which admitted female students from the time of its founding in 1867. The institution is a celebrated historically black university known for its academic rigor.

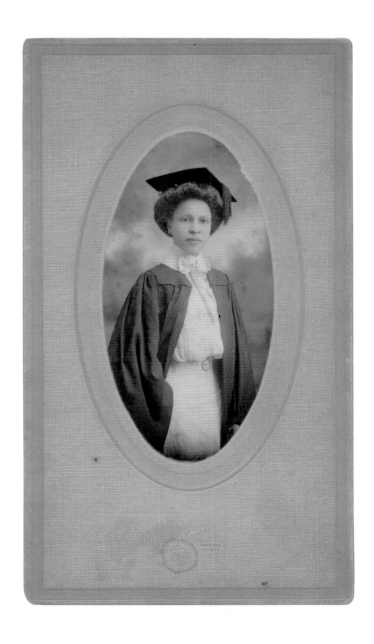

**Graduation portrait
of Octavia C. Long,**
June 1909
Unidentified
photographer

Leona Dean standing on a porch, 1919–25; printed 2012
John Johnson
—

Images shot by local photographer John Johnson in Lincoln, Nebraska, capture both candid and posed moments of a small but proud and thriving Midwestern African American community. In the state's capital, blacks experienced relatively integrated public schools and residential neighborhoods, but over time the employment and social practices became increasingly restricted along racial lines.

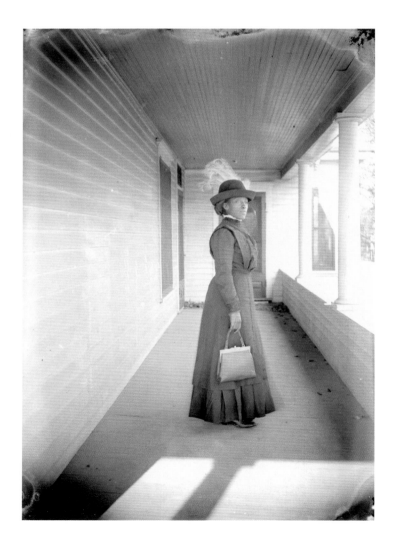

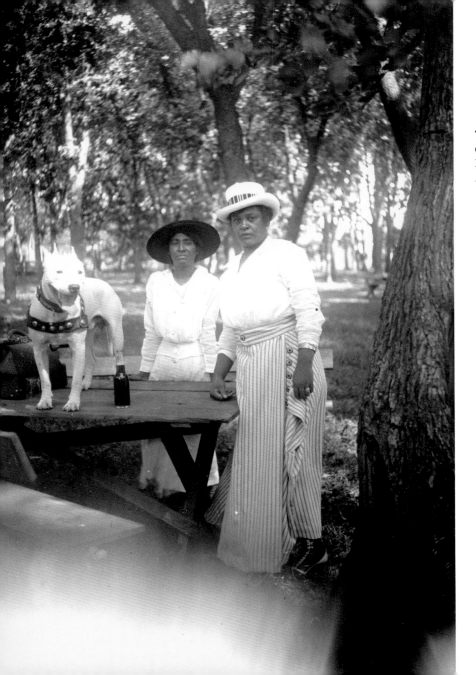

Two women and a dog standing outside, 1919–25; printed 2012
John Johnson

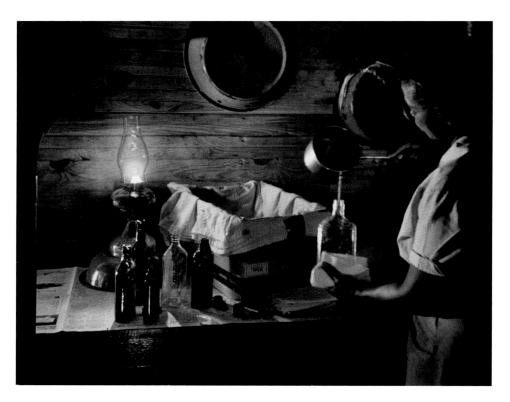

Midwives traditionally occupied a prominent position in African American communities, especially in the rural South. During slavery, older women skilled in delivering babies also served as healers and spiritual leaders, and maintained extensive social networks. In the early twentieth century, as modern medicine moved childbirth from the home to the hospital, many African American mothers continued to rely on midwives both for cultural reasons and because they lacked access to quality, affordable health care.

Untitled, 1951
W. Eugene Smith
—
Maude Callen, a nurse/midwife serving a rural South Carolina community, prepares for a birth by candlelight.

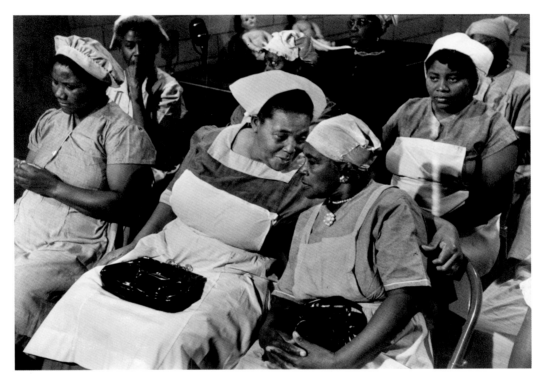

***Untitled (Among
Colleagues)***, 1952
From the series
**Reclaiming Midwives:
Stills from
*All My Babies***
Robert Galbraith

Produced by the Georgia
Department of Health,
the 1952 educational film
All My Babies featured
Mary Frances Hill Coley
(center), a practicing
midwife in Albany, Georgia,
who had delivered over

three thousand babies
during her career. UNESCO
and the World Health
Organization picked up the
film and used it to educate
midwives in training
throughout the world.

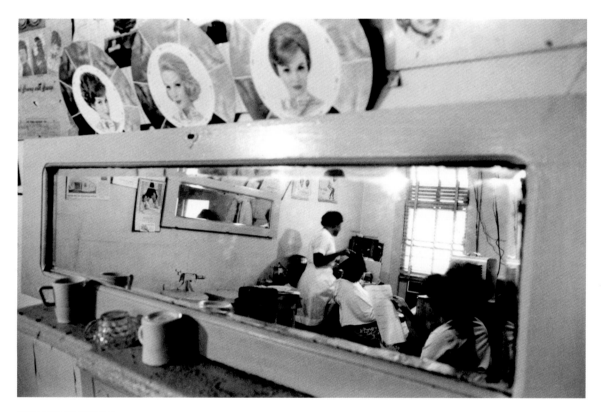

**Voter Registration
at a Beauty Shop,
Mississippi**, 1963–64;
printed 2008
Charles Moore

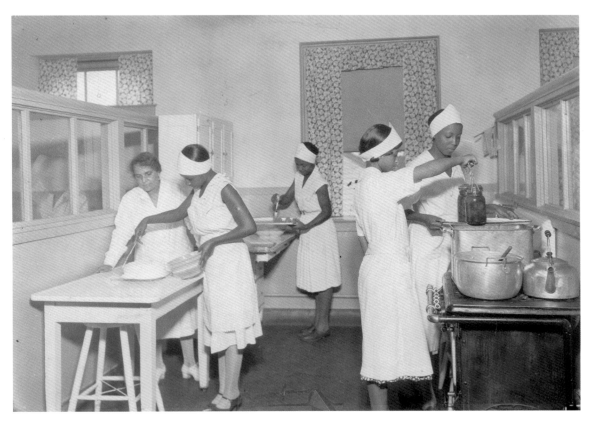

**Women working in
a kitchen at the
Bordentown School**,
ca. 1935
Lewis Wickes Hine

African–American Jewish Congregation in Harlem—Women Singing, 1940
From the series
The Commandment Keepers
Alexander Alland

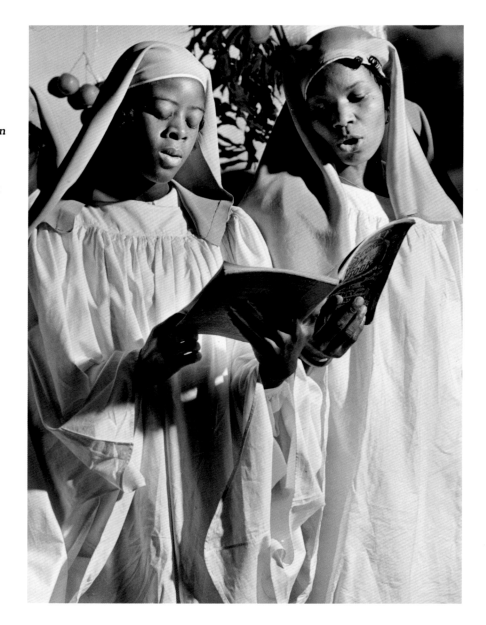

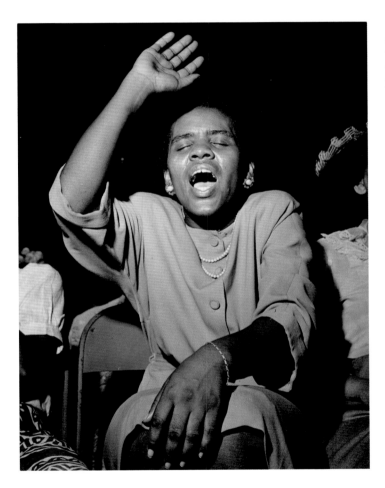

Untitled, 1946–48
Gospel services
From the series **The Way of Life of the Northern Negro**
Wayne F. Miller

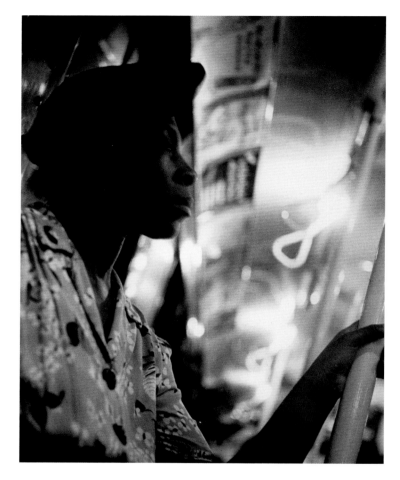

How Long? How Long? 1940s
Joe Schwartz

*"Many survivalists are women. All of
these folks deserve more representation."*

Joe Schwartz, 2000

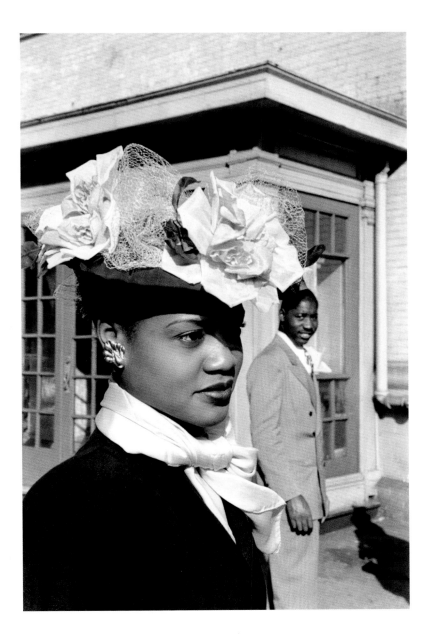

Easter Sunday, Harlem, 1947
Henri Cartier-Bresson

Untitled, 1940–41
From the series **The Most Crowded Block in the World**
Aaron Siskind
—

Best known for his abstract photography, Aaron Siskind also created several notable photo-essays in the 1930s and early 1940s featuring New York City. This image comes from one of the most powerful of these series, *The Most Crowded Block in the World.* Varied in subject and mood, it provides a lasting record of African American life in the city during the Great Depression.

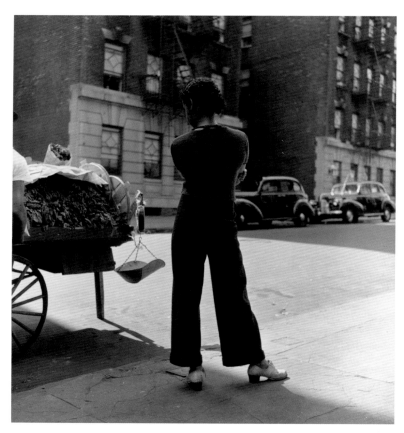

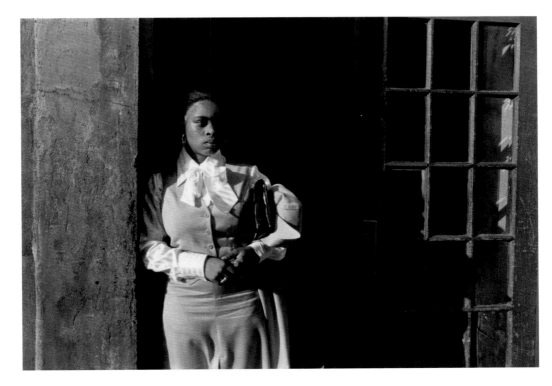

***A Woman Waiting in
the Doorway***, 1976;
printed 2005
From the series
Harlem, USA
Dawoud Bey

Katherine Dunham,
1960s
Louis H. Draper
—

Often called the
"matriarch and queen
mother of black dance,"
Katherine Dunham
(1909–2006) was also
a choreographer, social
activist, educator, and
anthropologist. During
the 1940s and 1950s, the
Katherine Dunham Dance
Company was renowned
throughout Europe, Latin
America, and the United
States for its modern
African and Caribbean
dance techniques. Over
her distinguished career,
Dunham choreographed
more than ninety dances.

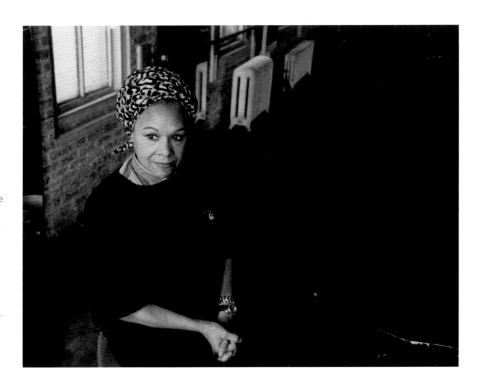

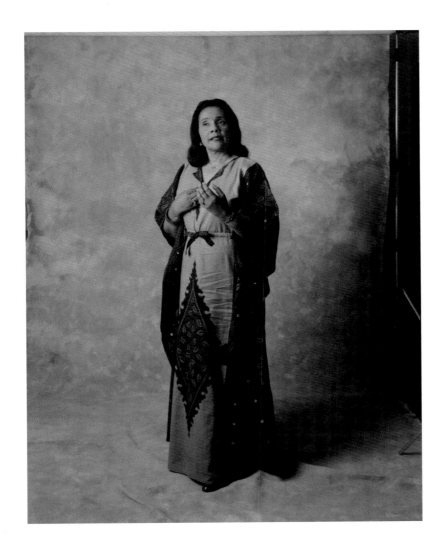

Coretta Scott King, Washington, D.C.,
1985
Thomas J. Shillea

—

Mrs. King (1927–2006), wife of Dr. Martin Luther King Jr., was a formidable individual in her own right. As well as being a trained musician, she was an impressive public speaker on behalf of social justice, and a mother of four. Throughout her life, she championed equal education and opportunity for all people, world peace, and preservation of the environment. On this occasion, according to the photographer, Mrs. King was in Washington to address the Congressional Black Caucus. She chose to be photographed in this "ceremonial tribal gown from one of the African countries she had just visited," and planned to wear it again for her speech the next day.

Joyce Bryant, 1978
Louis H. Draper
—
An internationally
acclaimed singer, Joyce
Bryant (b. 1928) is known
for her four-octave vocal
range. During the early
1950s, her suggestive
lyrics were often banned
from the radio, and her
guest appearances were
deleted from Hollywood
films. At the peak of her
career, Bryant walked
away from show business
to devote herself to
her faith. Later, Bryant
returned to the stage as
a classical vocalist and
secured a contract with
the New York City Opera.

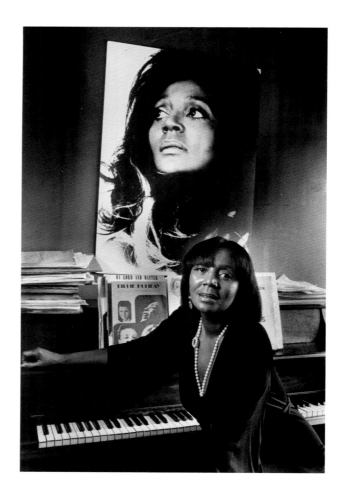

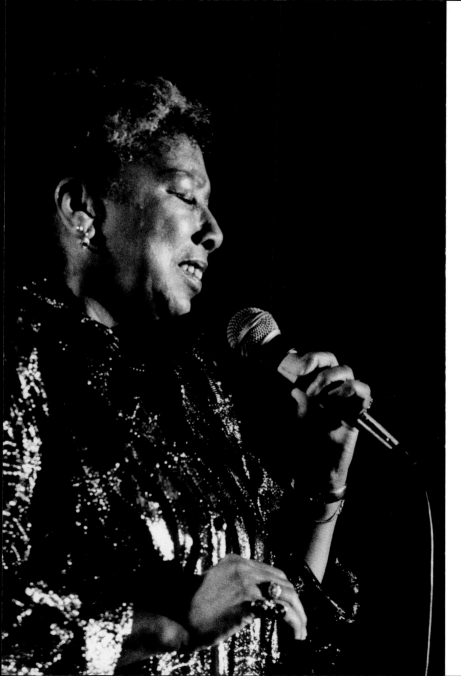

Etta Jones, 1989
David D. Spitzer

—

A Grammy-nominated jazz singer, Etta Jones (1938–2001) began her career singing at the famed Apollo Theater in Harlem. Over six decades, Jones recorded more than two dozen albums, and in 1960 climbed to number five on the R&B charts with the release of the single "Don't Go to Strangers." Jones continued to sing well into her sixties, earning a third Grammy nomination in 1999 for the album *My Buddy*.

Black Panther Mother and Her Newborn Son, Baby Jesus X, San Francisco, California, No. 125, October 1, 1968; printed 2010
From the series **Black Panthers 1968**
Ruth–Marion Baruch

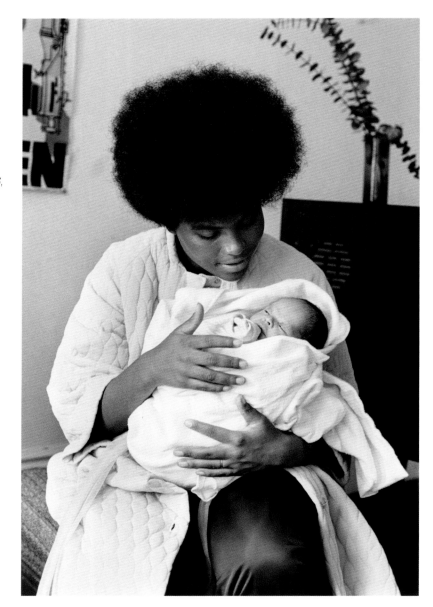

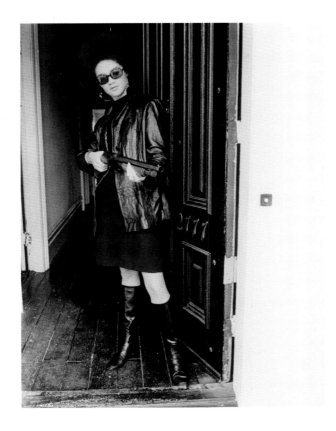

***Kathleen Cleaver
at Home***, 1968
Alan Copeland

"...the black woman must be given her full respect in life and not hampered in her abilities, in her desires, and her activities towards forwarding the liberation of her people."

Kathleen Cleaver, December 1971

Angeles Child, 1960s
Joe Schwartz

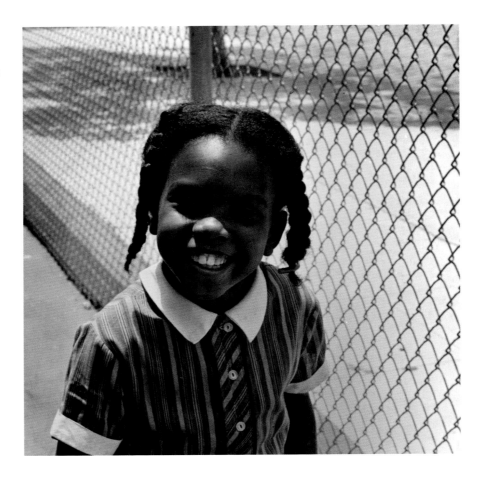

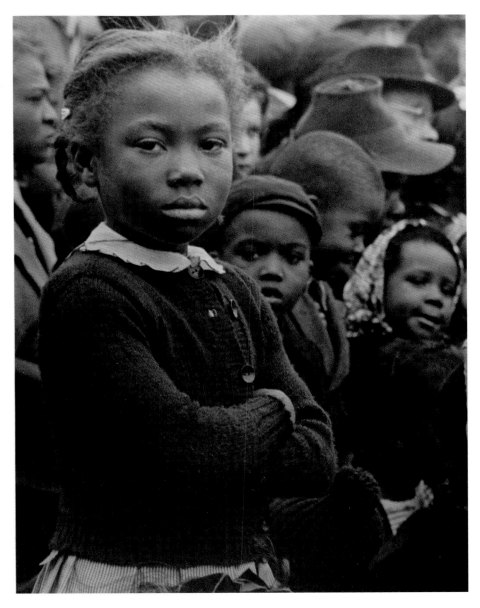

Miss America,
1940s
Joe Schwartz

Leesburg, Georgia.
Arrested for
Demonstrating in
Americus, Teenage Girls
Are Kept in a Stockade
in the Countryside, 1963;
printed 1994
Danny Lyon
—

In the summer of 1963, more than thirty young African American girls were held for forty-five days in the Leesburg Stockade for protesting in the streets of Americus, Georgia. That September, Danny Lyon, a twenty-year-old photographer for the Student Nonviolent Coordinating Committee (SNCC), snuck onto the stockade grounds and spoke to the girls through a broken window while photographing them and the horrid living conditions inside the cell. Once processed, the photos were passed to a U.S. congressman who entered them into the Congressional Record. This caught the attention of the national media and Attorney General Robert Kennedy and eventually led to the girls' release.

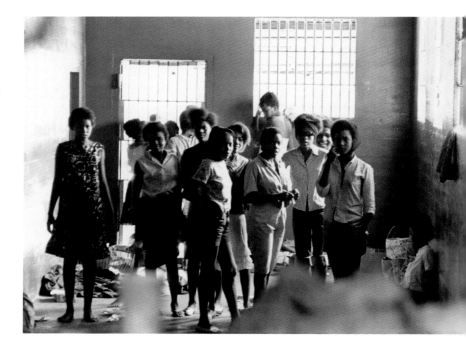

"All I did was make pictures. But in Americus, my pictures had actually accomplished something. They had gotten people out of jail."

Danny Lyon, 1992

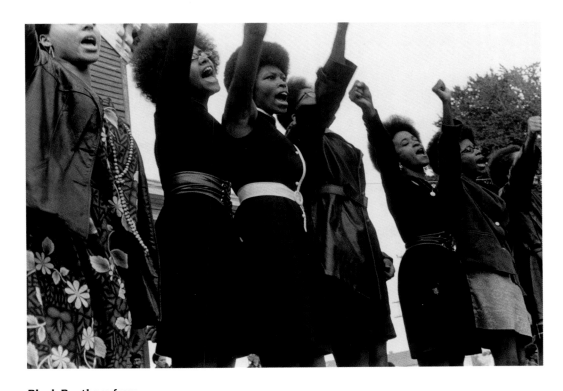

***Black Panthers from
Sacramento, Free
Huey Rally, Bobby
Hutton Memorial
Park, Oakland,
California, No. 62***,
August 25, 1968;
printed 2010
From the series
Black Panthers 1968
Pirkle Jones

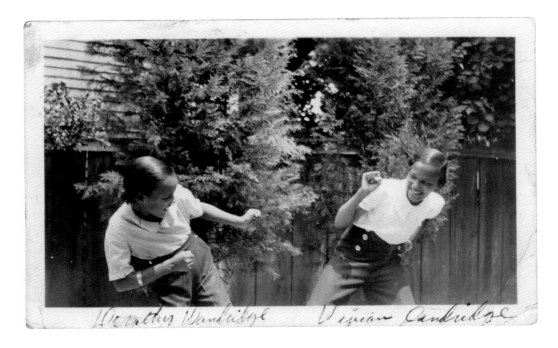

**Sisters Dorothy and
Vivian Dandridge**,
1930s
Unidentified
photographer

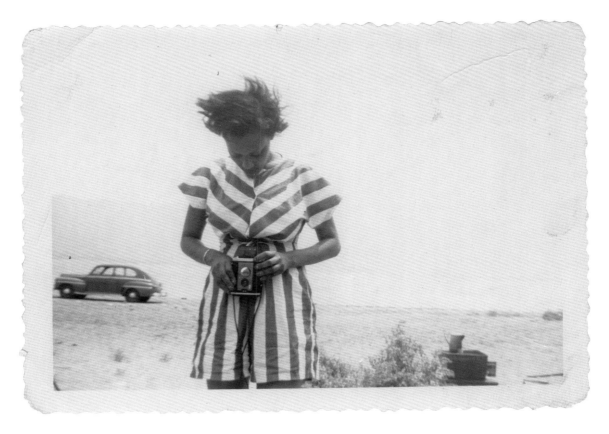

**A Day at the Beach:
Vivian Dandridge**,
late 1940s
Unidentified photographer

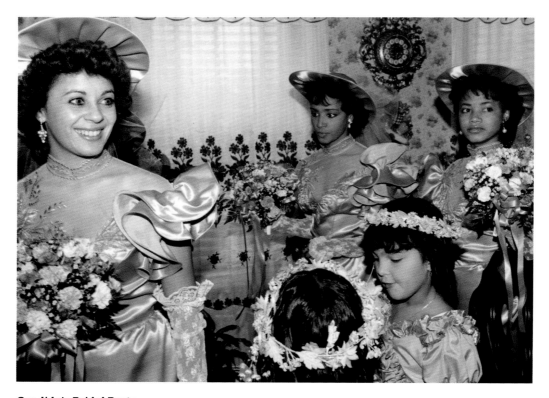

***Candida's Bridal Party,
Chelsea***, 1986–90
From the series **Cape
Verdeans in the Boston
Area of Massachusetts and
in the Cape Verde Islands**
Beverly Conley

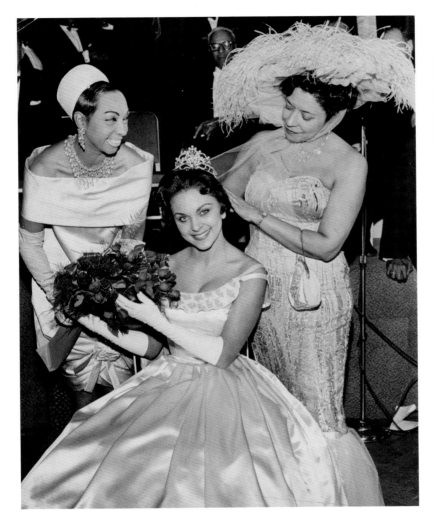

Josephine Baker and Mollie Moon crowning Dolores Mae Daniels, the Beaux Arts Queen, 1960
Cecil Layne

**Gladys Bentley:
America's Greatest
Sepia Player—The
Brown Bomber of
Sophisticated Songs**,
1946–49
Harry Walker Agency
–
Gladys Bentley (1907–
1960), an entertainer of the
Harlem Renaissance,
performed with a chorus
line of drag queens at the
Ubangi Club. Dressed in
men's clothing, Bentley
played piano and sang racy
lyrics to popular tunes
while growling in a deep
voice and flirting with
women in the audience.

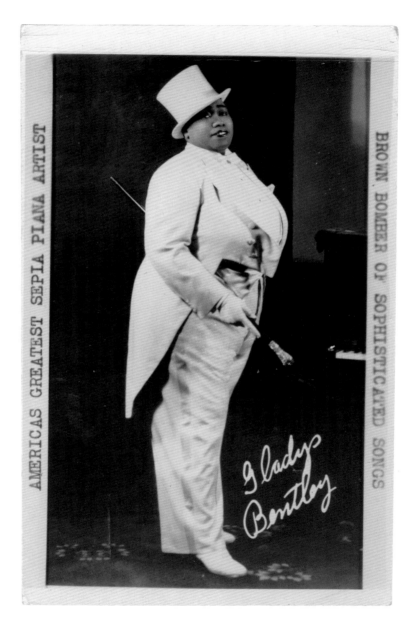

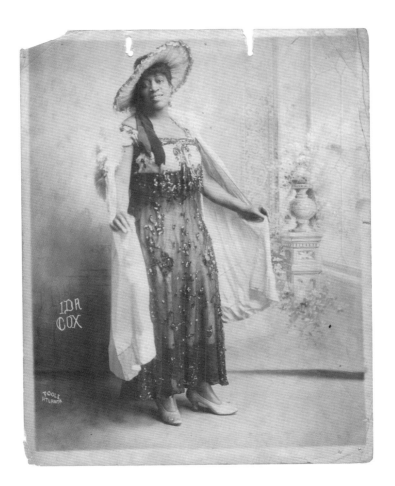

Ida Cox, 1920s
Paul Poole

—

Touted as "The Uncrowned Queen of the Blues," by age 14 Ida Cox (1896–1967) was traveling the South in vaudeville and tent shows as both a singer and a comedienne. Cox was soon a headline act, performing throughout the East Coast and Midwest. Her strong stage presence—which often included regal costumes, tiaras, a cape, and a rhinestone wand—garnered attention from Paramount Records. Between 1923 and 1929, Cox recorded seventy-eight titles, including "Nobody Knows You When You're Down and Out" and "Wild Women Don't Have the Blues."

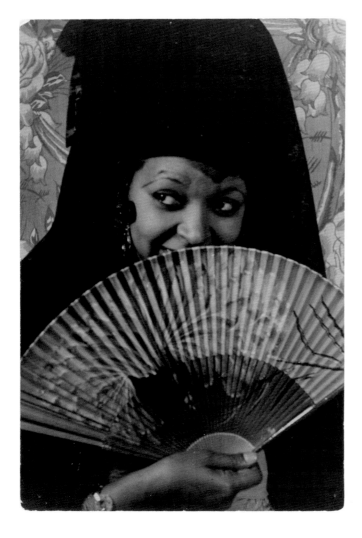

Ethel Waters as Carmen, April 30, 1934
Carl Van Vechten

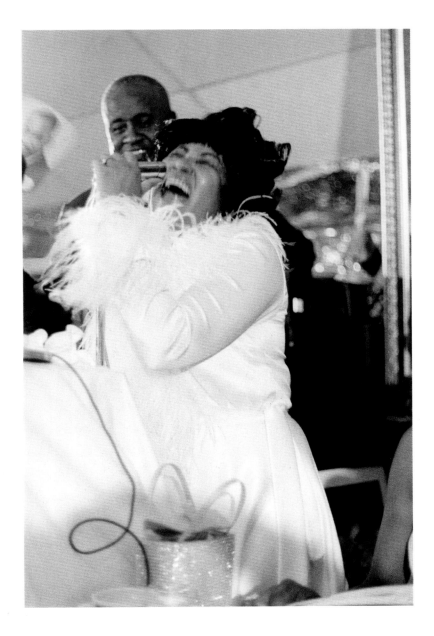

Aretha Franklin, Southern Christian Leadership Conference Convention, Club Paradise, Memphis, Tennessee, July 1968
Ernest C. Withers

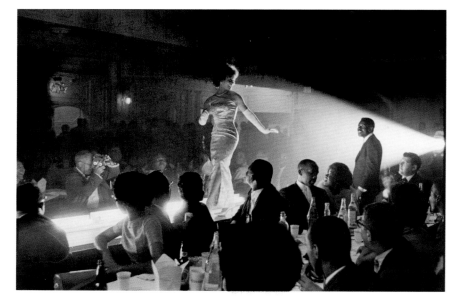

Harlem Beauty Contest · New York, New York, 1963; printed 1998
Leonard Freed

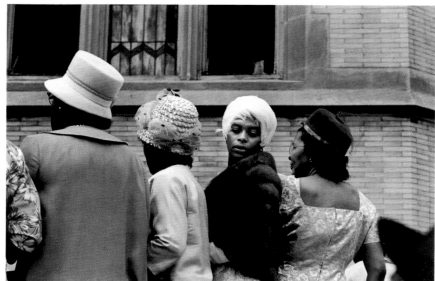

Untitled (Wedding Day), 1962–63; printed 2010
Jan Yoors

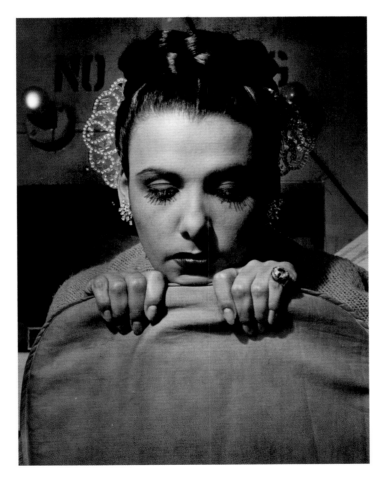

Untitled, May 1947
**Lena Horne
backstage at the
Chez Paree**
From the series **The
Way of Life of the
Northern Negro**
Wayne F. Miller

***Alvin Ailey and
Carmen De Lavallade
in Roots of the Blues***,
1961; printed 1993
Jack Mitchell

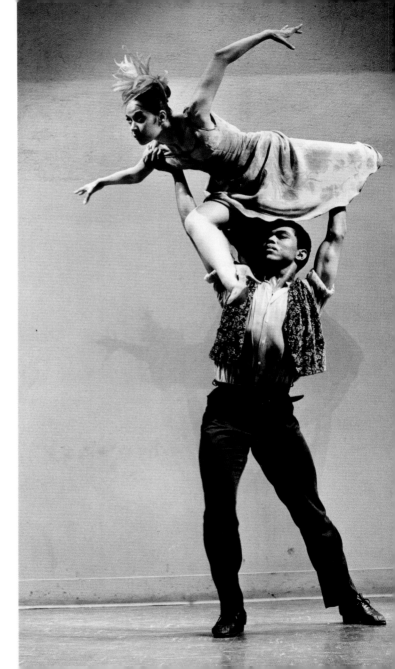

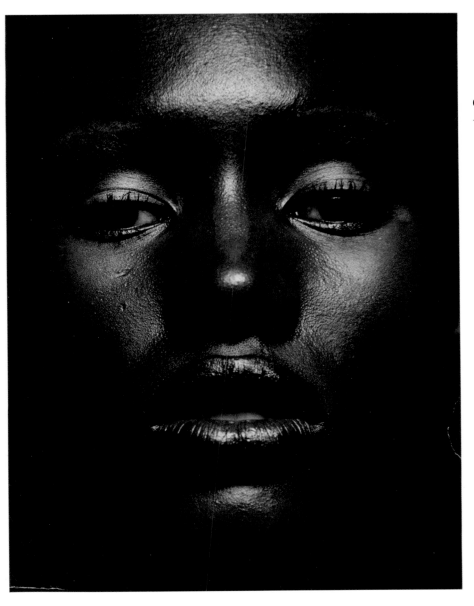

Grace Jones, 1970s
Anthony Barboza

Index

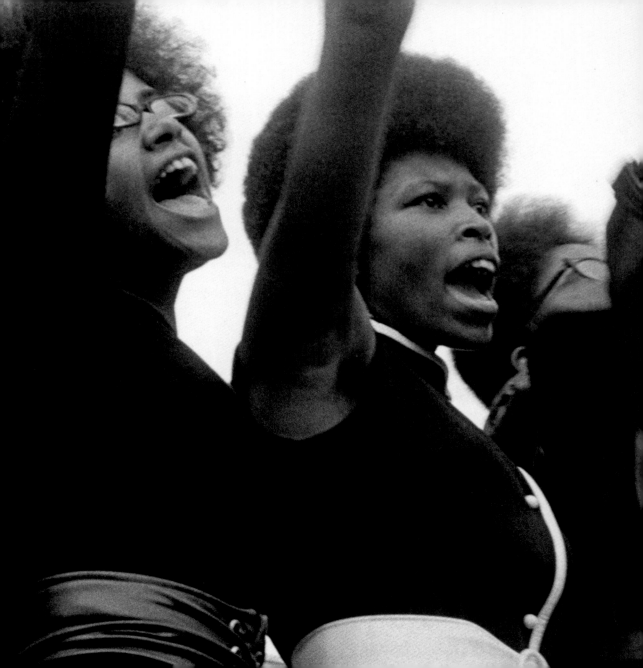

W. Eugene Smith
Untitled, 1951
gelatin silver print
H x W (Image and Sheet):
13⅜₁₆ x 9⅜ in. (33.8 x 23.8 cm)
Purchased with funds provided
by The Philip and Edith Leonian
Foundation
2013.114.14
© W. Eugene Smith – Time and
Life Pictures/Getty Images
Page 17

W. Eugene Smith
Untitled, 1951
gelatin silver print
H x W (Image and Sheet):
10¹⁵⁄₁₆ x 13¾ in. (27.8 x 34 cm)
Purchased with funds provided
by The Philip and Edith Leonian
Foundation
2013.114.10
© W. Eugene Smith – Time and
Life Pictures/Getty Images
Page 36

David D. Spitzer
Etta Jones, 1989
gelatin silver print
H x W (Image and Sheet):
13¹¹⁄₁₆ x 10¾ in.
(34.8 x 27.3 cm)
Gift of David D. Spitzer
2012.164.144
© David D. Spitzer
Page 49

Tarby Studios
Harriet Tubman, ca. 1908;
printed ca. 1920
albumen print
H x W (Image and Sheet):
9⅞ x 8 in. (25.1 x 20.3 cm)
Gift of Charles L. Blockson
2009.50.2
Page 10

Unidentified photographer
*A Day at the Beach: Vivian
Dandridge*, late 1940s
gelatin silver print
H x W (Image and Sheet):
3½ x 5 in. (8.9 x 12.7 cm)
Gift of Jackie Bryant Smith
2010.66.39
Page 57

Unidentified Photographer
**Graduation portrait of Octavia
C. Long**, June 1909
gelatin silver print
H x W (Image and Mat):
9 x 5¼ in. (22.9 x 13.3 cm)
Gift of Naomi Long Madgett
2011.79.10
Page 33

Unidentified Photographer
**Linnie King and Virginia Bryant
Williams**, 1941
gelatin silver print
H x W (Image and Sheet):
5⁷⁄₁₆ x 3⁷⁄₁₆ in. (13.8 x 8.7 cm)
Gift of Jackie Bryant Smith
2010.66.116
Page 25

Unidentified Photographer
**Odessa Jones Murray in front
of a car**, ca. 1940
gelatin silver print
H x W (Image and Sheet):
2¾ x 4½ in. (7 x 11.4 cm)
Gift of Jackie Bryant Smith
2010.66.119
Page 24

Unidentified Photographer
Rhoda Phillips, ca. 1850
daguerreotype
H x W (Case open):
3 x 5 in. (7.6 x 12.7 cm)
H x W (Case closed):
3 x 2½ in. (7.6 x 6.4 cm)
2011.34
Pages 28, 29

Unidentified Photographer
Sojourner Truth, ca. 1866
albumen carte-de-visite
H x W (Image and Mount):
4 x 2½ in. (10.2 x 6.4 cm)
2012.46.11
Page 26

Unidentified Photographer
**Sisters Dorothy and Vivian
Dandridge**, 1930s
gelatin silver print
H x W (Image and Sheet):
2¾ x 4½ in. (7 x 11.4 cm)
Gift of Jackie Bryant Smith
2010.66.4
Pages 56, 68

Unidentified Photographer
A woman and child, ca. 1860
ambrotype
H x W (Case open):
3⅞ x 7 x ⅝ in.
(9.8 x 17.8 x 1.6 cm)
H x W (Case closed):
3⅞ x 3½ x ⅞ in.
(9.8 x 8.9 x 2.2 cm)
Gift from the Liljenquist Family
Collection
2011.51.11
Page 30

Carl Van Vechten
Ethel Waters as Carmen,
April 30, 1934
gelatin silver print
H x W (Image and Sheet):
9½ x 6¼ in. (24.1 x 15.9 cm)
2010.42.4
© Carl Van Vechten Trust
Pages 13, 62

Milton Williams
Untitled, ca. 1980
gelatin silver print
H x W (Image and Sheet):
8⅛ x 5¹⁄₁₆ in. (20.6 x 12.9 cm)
Gift of Milton Williams Archives
2011.15.391
© Milton Williams
Page 22

Ernest C. Withers
*Aretha Franklin, Southern
Christian Leadership Conference
Convention, Club Paradise,
Memphis, Tennessee*, July 1968
gelatin silver print
H x W (Image and Sheet):
20 x 16 in. (50.8 x 40.6 cm)
2009.16.19
© Ernest C. Withers Trust
Page 63

Ernest C. Withers
*Helen Ann Smith at Harlem
House, Beale St., Memphis,
Tennessee*, 1950s
gelatin silver print
H x W (Image and Sheet):
14 x 11 in. (35.6 x d 27.9 cm)
2009.16.17
© Ernest C. Withers Trust
Page 20

Jan Yoors
Untitled (Wedding Day), 1962–63;
printed December 2, 2010
digital print
H x W (Image and Sheet):
10⅞ x 13¹⁵⁄₁₆ in.
(27.6 x 35.4 cm)
Courtesy of Yoors Family and
L. Parker Stephenson Gallery
2011.162.7
© 2010 Jan Yoors
Page 64